MW01016522

paperblanks®

WHIMSICAL CREATIONS

Laurel Burch était une artiste autodidacte issue de la génération hippie qui, dans les années 60, vendait ses bijoux dans les rues de San Francisco. Plus tard, douée de ce tempérament intuitif et créateur qui était sien, elle poursuivit son travail artistique avec une vitalité créatrice étonnante. Témoignant de son amour pour la vie, elle a peint et dessiné des sujets joyeusement colorés, illuminés d'or et d'argent.

Laurel Burch hat nie eine akademische Ausbildung durchlaufen. Als typisches Blumenkind der 60er Jahre verkaufte sie lieber ihren handgearbeiteten Schmuck auf den Straßen von San Francisco. Intuition und Leidenschaft waren zu jeder Zeit Motor ihrer starken emotionalen Ausdruckskraft und ihres unverwechselbaren Stils: Laurel Burch liebte das Leben und die Fantasie. Mit ihrer imaginativen Kraft schuf sie lebendige und bewegende Themen in leuchtenden Farben, verziert mit Gold und Silber.

Laurel Burch, artista autodidatta e "figlia dei fiori", vendette negli anni '60 bigiotteria fatta a mano per le strade di San Francisco. Più tardi continuò ad affidarsi al proprio intuito e alla propria passione, parlando dal cuore con uno stile inconfondibile che rivelò il suo amore per la vita e la sua natura fortemente immaginativa. Dalla sua fertile creatività nacquero soggetti vibranti, toccanti e variopinti, che l'artista trasferì su carta e lumeggiò d'oro e d'argento.

Laurel Burch fue una artista autodidacta, hija de la generación hippie. Ya en los años sesenta se dedicaba a la venta de joyería artesanal en las calles de San Francisco. Después, siguió confiando en su intuición y en su pasión para expresar el lenguaje del corazón con un estilo inconfundible que reflejaba su amor por la vida y su naturaleza fuertemente creativa. Su fértil imaginación le permitió crear con papel y pintura temas brillantemente coloreados, vibrantes y conmovedores, exquisitamente adornados con oro y plata.

フラワーチルドレンの一人で、1960年代にはサンフランシスコの街角で手作りのアクセサリーを売っていたローレル・バーチ。独学のアーティストであり、後には直感と情熱のおもむくままに、個性的かつ豊かなイメージを創り出すようになる。その豊かな想像力は、絵の具と紙を媒体に金銀で絶妙なアクセントを施し、色鮮やかで躍動感あふれる作品を生み出した。

122240

paperblanks®

WHIMSICAL CREATIONS

Ocean Song

Laurel Burch was a self-taught artist and "flower child" who sold handmade jewellery on the streets of San Francisco in the 1960s. Later on, she continued to rely on her intuition and passion, speaking from the heart with an unmistakable style that was the manifestation of her love of life and strong imaginative nature. From her fertile imagination, she created brilliantly coloured, vibrant and moving themes with paint and paper, exquisitely embellished with gold and silver.

ISBN: 978-1-4397-2236-7
MIDI FORMAT 160 PAGES LINED
DESIGNED IN CANADA

Artwork © Laurel Burch™
Printed on acid-free sustainable forest paper.
Book design © 2012 Hartley & Marks Publishers Inc. All rights reserved.
No part of this book may be reproduced without written permission
from the publisher. Paperblanks® are published by
Hartley & Marks Publishers Inc. and
Hartley & Marks Publishers Ltd. Made in China.
North America 1-800-277-5887
Europe +800-3333-8005
Japan 0120-177-153
www.paperblanks.com